TOTEM POLES
OF THE NORTHWEST

by D. ALLEN

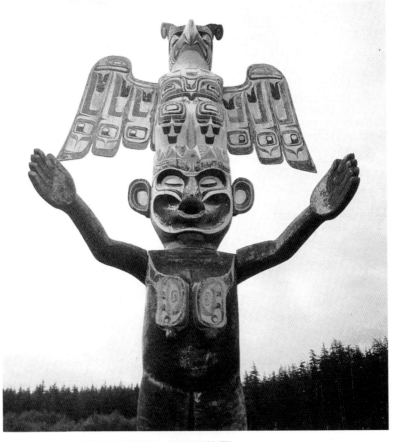

CARVED BY WILLIE SEWID, KWAKIUTL

THE TOTEM POLE

HORIZONTAL MEMORIAL

A totem pole is made up of symbolic figures or crests commemorating a vision, event or death. They surely represent one of the most sophisticated, bold and distinctive art forms of the Amerindians. They were never worshipped — except perhaps in modern times by art collectors. Western red cedar was carved exclusively, using stone tools until Eurasians introduced metal. The large poles seen today were not carved before white men arrived on the coast.

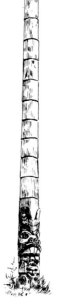

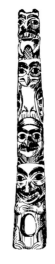

HOUSE FRONTAL

MEMORIAL

DRAWINGS BY SUSAN IM BAUMGARTEN

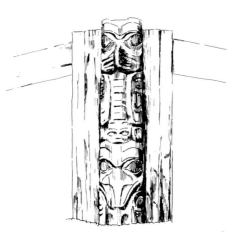

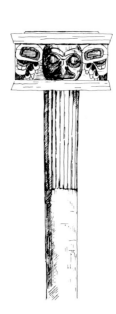

INSIDE HOUSE POST 2 **MORTUARY**

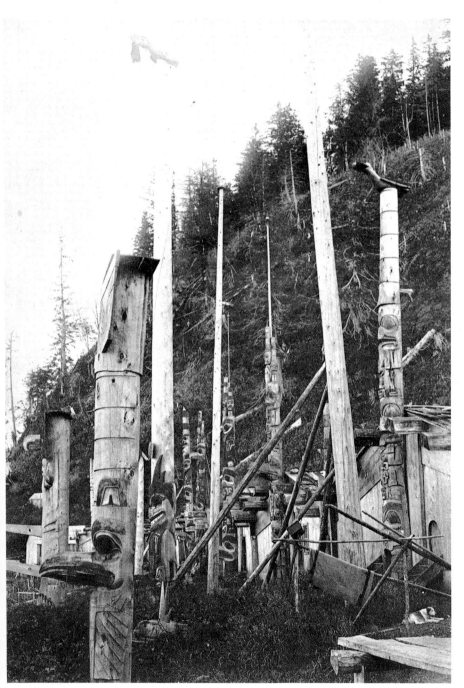

HAIDA VILLAGE, NEW GOLD HARBOUR

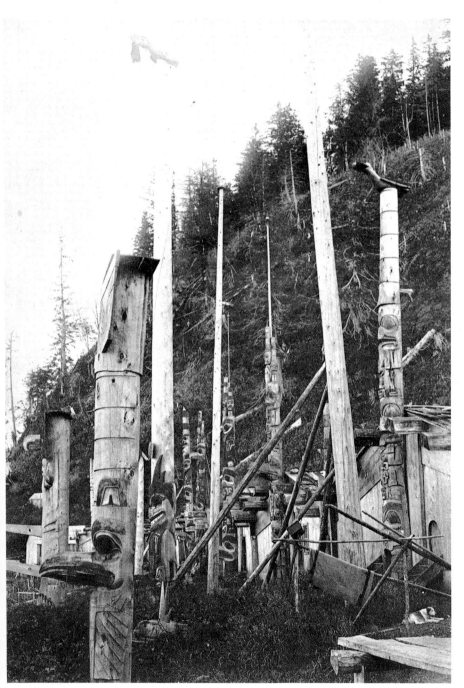NAT. MUSEUM

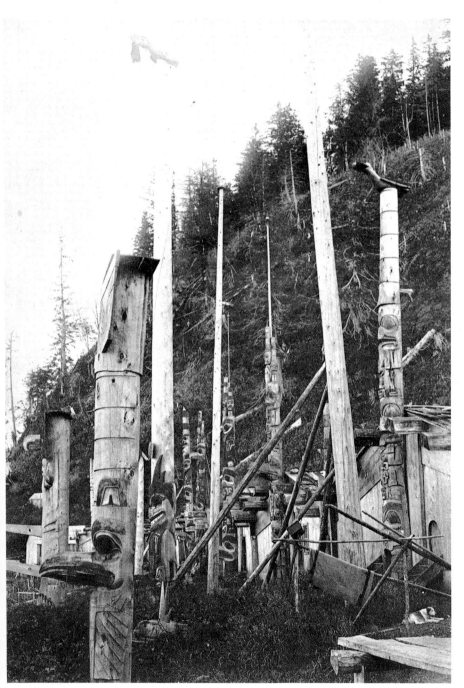3

CRESTS

COPPER

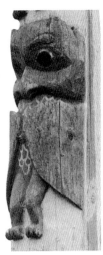

OWL

The totem pole, like a coat-of-arms, is built up of distinct elements or crests representing real animals, people or objects, or supernatural beings which in turn often represented families or clans. Each crest figure had tell-tale distinguishing marks: the Beaver always had a checkerboard tail, the Killer Whale a dorsal fin, the Thunderbird a carved beak and horns, the Eagle—no horns, etc. While the crest may represent a specific animal, for example Wolf, each wolf carved could represent a different personalized story. Therefore, without knowing the owner's story it is not possible to completely understand or read a pole except as a listing of crests.

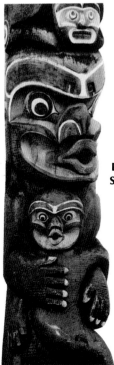

DSONOQUA
STEALING BABY

MOUNTAIN
GOAT

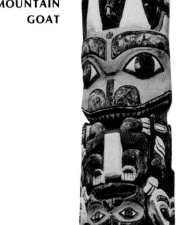

4

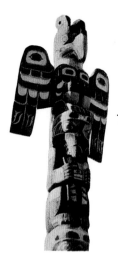

THUNDERBIRD

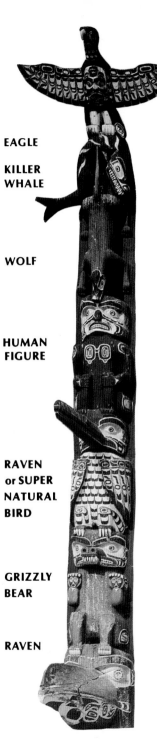

EAGLE

KILLER WHALE

WOLF

HUMAN FIGURE

RAVEN or SUPER NATURAL BIRD

GRIZZLY BEAR

RAVEN

MOSQUITO or HUMMINGBIRD

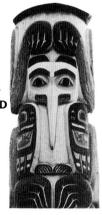

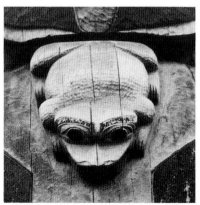

FROG

5

MEMORIAL POLES

Memorial or heraldic poles, portraying family crests or stories, were raised to commemorate special events such as potlatches, great battles or significant dreams or visions.

A **KWAKIUTL MEMORIAL.** It is characteristic of Kwakiutl style to portray Thunderbird or Eagle with the wings open. Here Thunderbird rests on Bear.

B **HAIDA HORIZONTAL MEMORIAL.** From Tanoo in 1911 depicts "Whale in grasp of Thunderbird", a common recurring theme.

A

ED COOPER

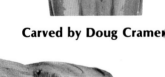

Carved by Doug Cramer

B

C **HAIDA MEMORIALS.** These modern replicas stand at Prince Rupert.

6

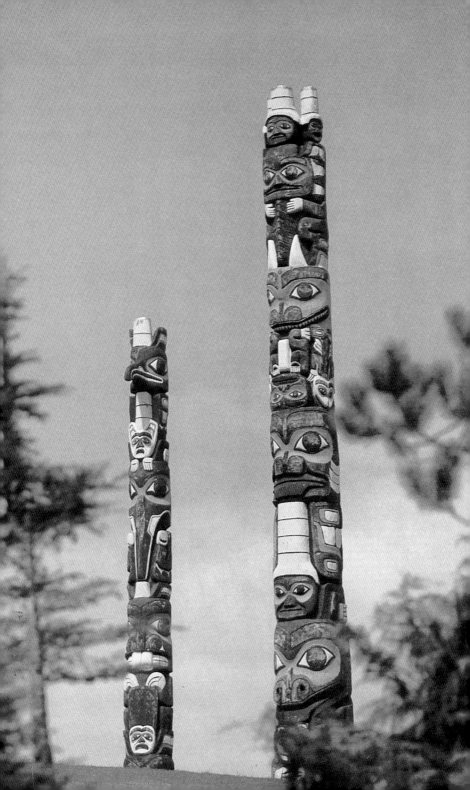

MORTUARY POLES

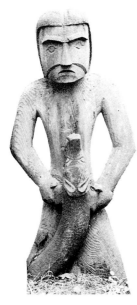

Mortuary poles were only erected as a chief's or shaman's grave post. They often held his body or ashes on the top. Rarely the Haida burial box was supported by two poles. In some areas horizontal and grave figures served as mortuary poles.

A **GRAVE FIGURE.** Coast Salish.

B **HAIDA MORTUARIES.** From Skedans.

C **CHIEF SKEDANS' MORTUARY.** Shown on the right, this replica is standing in Vancouver. It was originally erected in honor of Chief Skedans prior to 1850 at a cost of 290 blankets ($580.00). The crest figures, top to bottom, are: Moon, Mountain Goat, and out of sight below, Grizzly Bear, Killer Whale, and Human.

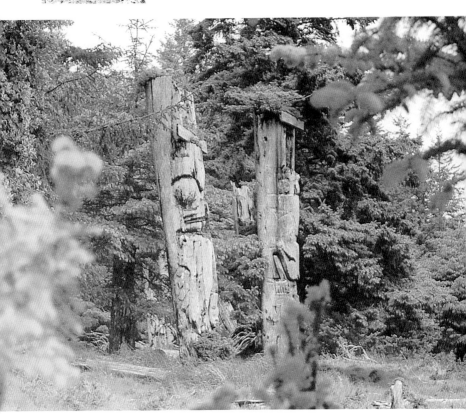

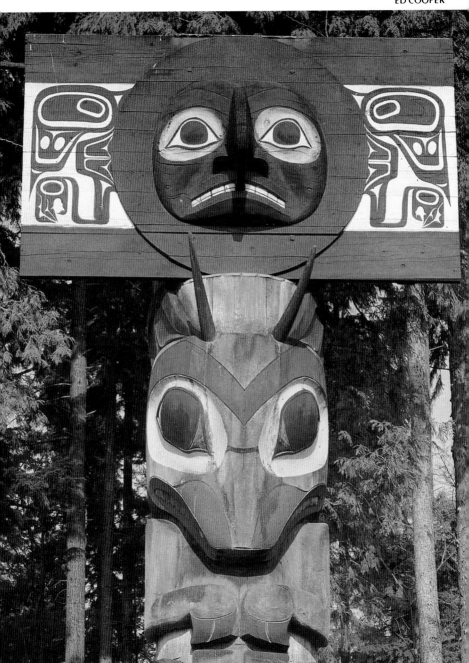

HOUSE POLES

House poles, another form of memorial or heraldic pole, were of two kinds. House frontal poles had a hole cut into the front through which entrance was made to the house. Inside house posts were an integral part of the structure, supporting the large roof beams.

A **TSIMSHIAN HOUSE FRONTAL.** From 'Ksan on Skeena River near Hazelton.

B **KWAKIUTL INSIDE HOUSE POST.** From Knight Inlet, this was a corner post on an unfinished house.

C **TLINGIT HOUSE FRONTAL.** This Alaskan house illustrates extreme in frontal design. Pole crest figures (top to bottom): Thunderbird, Bear, Frog, Crying Human, Killer Whale, and possibly two other variations of supernatural Human.

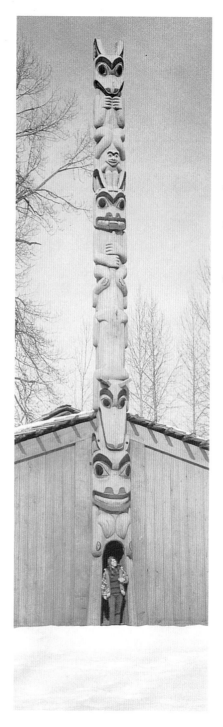

MUSEUM OF MAN NAT. MUS.

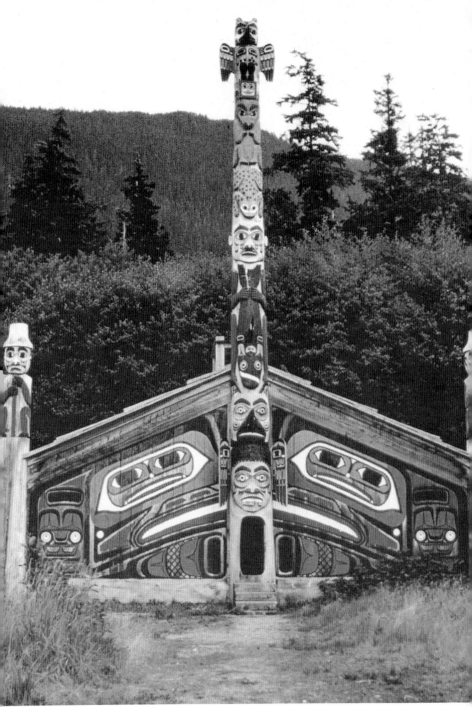

MUSEUM OF MAN NAT. MUS.

SALISH

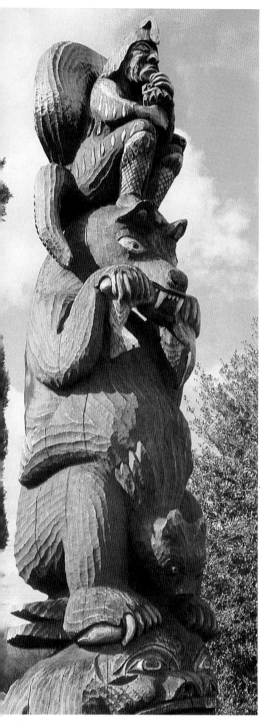

EAGLE FIGURE.

The salish did not carve tall elaborate memorial or mortuary poles but rather concentrated on smaller figures, which either stand alone as a grave post in a graveyard or inside or outside a house as a heraldic house post.

SPIRIT DANCER WEARING PADDLE JACKET, SEA SERPENT, BEAR WITH FISH AND CUB.
by Simon Charlie

by Simon Charlie

12

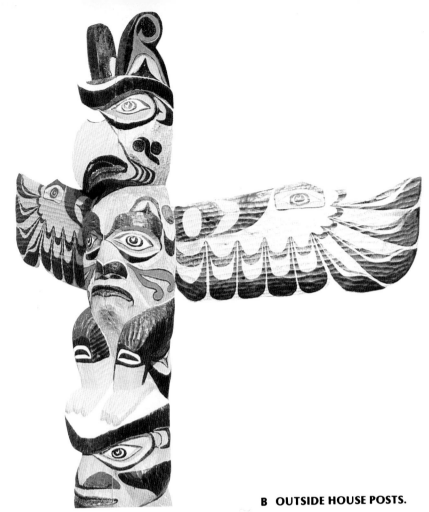

B OUTSIDE HOUSE POSTS.

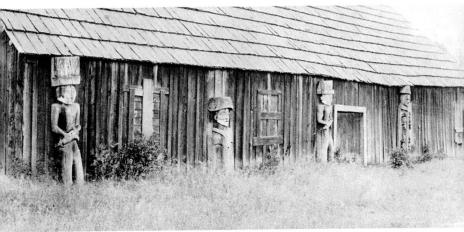

MUSEUM OF MAN NAT. MUS.

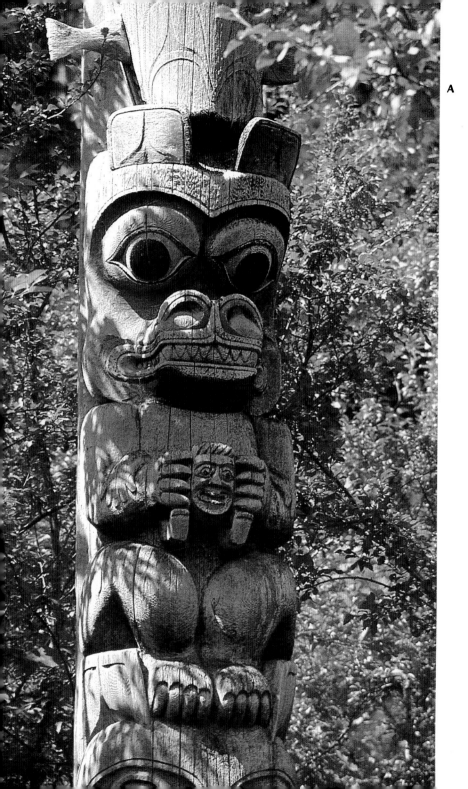

WEST COAST OR NOOTKA

The Nootka carved both fine tall poles and smaller welcoming figures, though few over 50 years of age remain standing today.

A GRAVEYARD BAY MEMORIAL
From the village just south of Cape Cook shows a Bear crest figure clutching a baby, probably portraying a version of the Bear-Mother story.

B WELCOMING FIGURE
Nuchalaht village at entrance to Esperanza Inlet, originally had its arms extended as a gesture of welcome.

C EHATISAHT MEMORIAL AT HOX

C

B

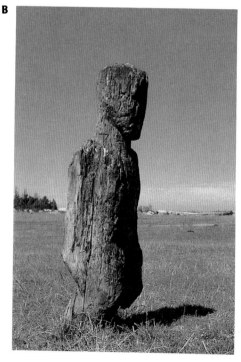

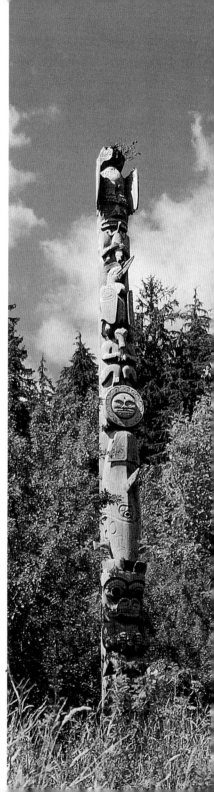

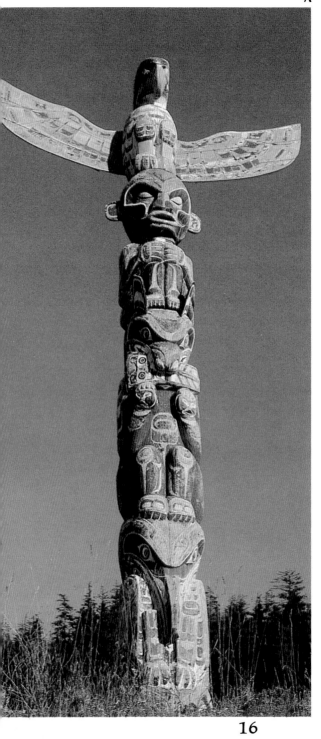
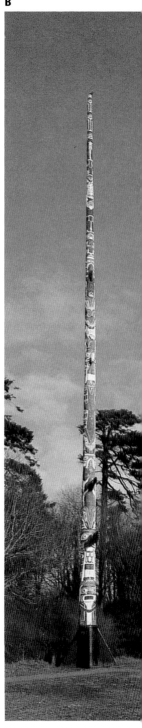

KWAKIUTL

The Kwakiutl of central British Columbia were and still are some of the most prolific and innovative totem carvers. Their poles are elaborate and brightly painted. Thunderbird, ruler and master of the skies and earth, is a prominent crest, usually portrayed with his wings extended. The Kwakiutl, more than any other group, ornately painted their house frontal poles.

A MEMORIAL POLE. From Alert Bay (T to B): Thunderbird, Dsonoqua (Wild Woman of the Woods), Wolf holding Copper in mouth, Raven.

B MEMORIAL POLE. Beacon Hill Park, Victoria.

C EAGLE CREST FIGURE. A modern replica.

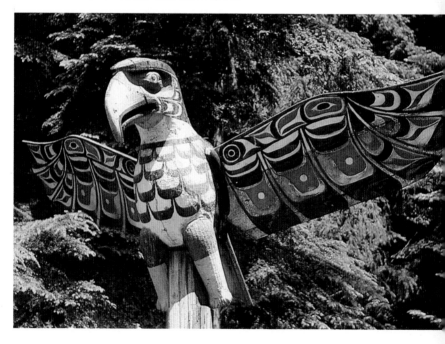

RAISING OF A POLE

Probably no carver is better known or has done more for the art and appreciation of the totem than Mongo Martin. Here the Mongo Martin Memorial Pole is erected at Alert Bay. Crests are: Thunderbird, Human with Copper and Talking Stick, Raven, and Dsonoqua.

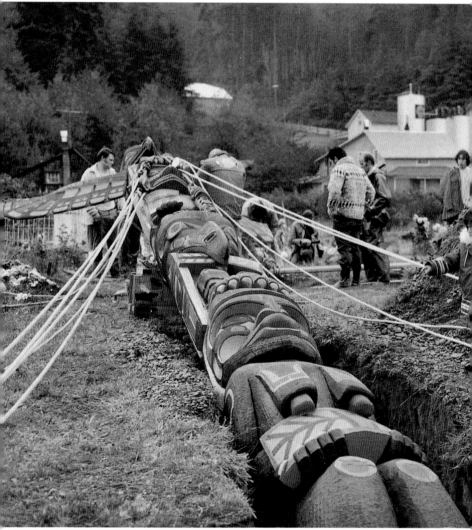

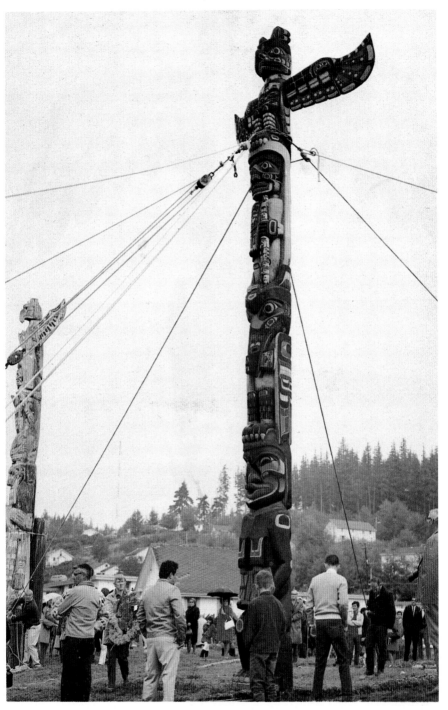

B.C. GOV'T.

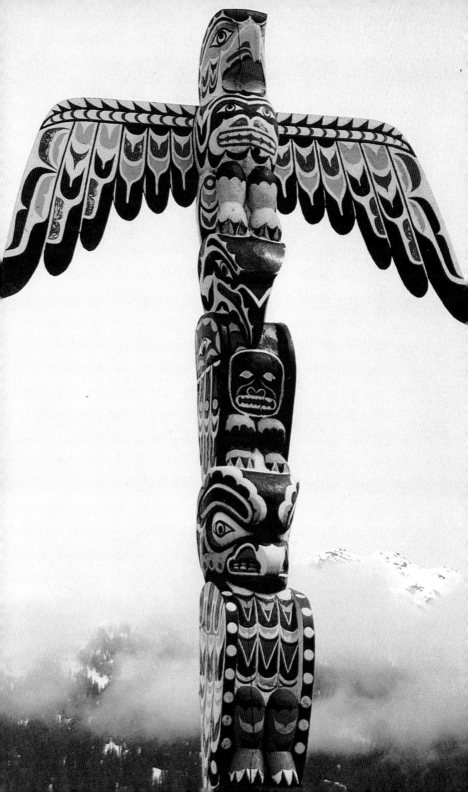

BELLA COOLA

Like the nearby Kwakiutl who nearly surround them, the Bella Coola carved elaborate colorful poles. The nearby snowy mountain peaks give a magnificent setting to their villages along shores of the Bella Coola River and Dean and Burke Channels.

A BELLA COOLA MEMORIAL.

B BELLA COOLA HOUSE FRONTAL. A very innovative modern design.

C HOUSE FRONTAL. Bella Coola.

B

C

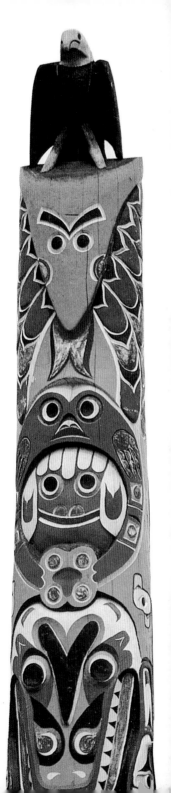

A

21

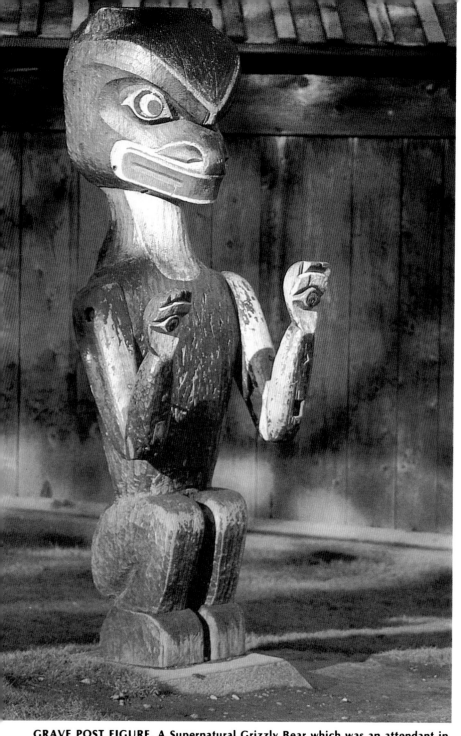

GRAVE POST FIGURE. A Supernatural Grizzly Bear which was an attendant in the house of the Cannibal Spirit. It has an extra set of eyes on its hands. Now located in Thunderbird Park, Victoria.

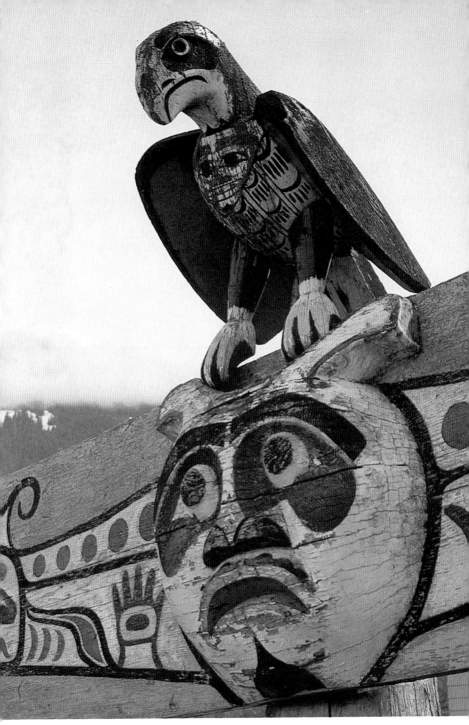

EAGLE-TWO-HEADED SERPENT GRAVE MARKER. Bella Coola.

HAIDA

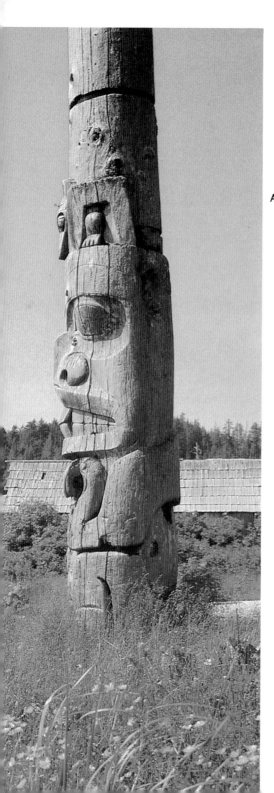

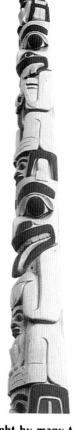

A B

The Haida are thought by many to have had the most skilled artistry though they did not so elaborately paint their poles as did some neighbours. The largest collections of old standing poles occur at the abandoned villages of Ninstints and Skedans on the southern Queen Charlotte Islands.

A **MEMORIAL POLE.** Skidegate.

B **MASSET POLE.**
Carved by Robert Davidson.

C **MORTUARY POLE.** Showing tree filled hollow at top for burial box. Sun bleached relic is about to topple.

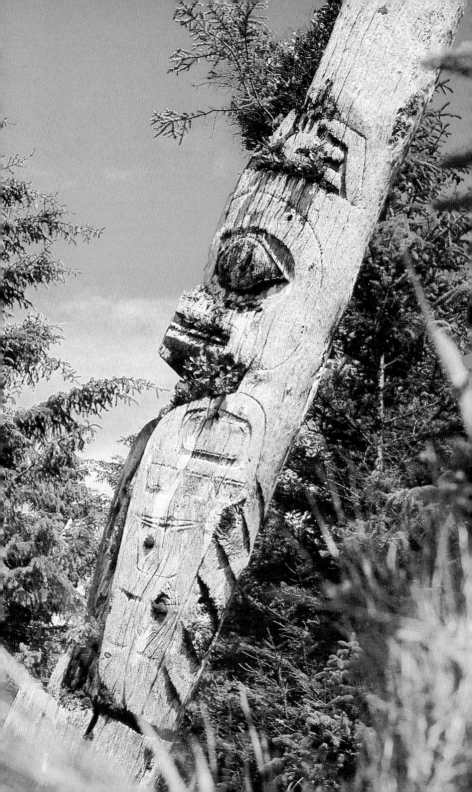

TSIMSHIAN

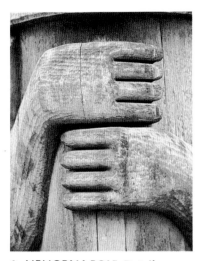

The peoples of the Nass and Skeena Rivers, from the Coast inland one hundred miles, lived in villages abounding with tall cedar poles. Most famous is 'Ksan, a modern rebuilt village on the banks of the Skeena River near Hazelton. Here classes are held to teach the traditional art form and carving techniques. Dances, ceremonies, crafts, and even a modern trailer court are provided for the visitor to the reserve.

A MEMORIAL POLE. Details.

C THUNDERBIRD clutching Human crest on house frontal at 'Ksan.

B 'KSAN VILLAGE.

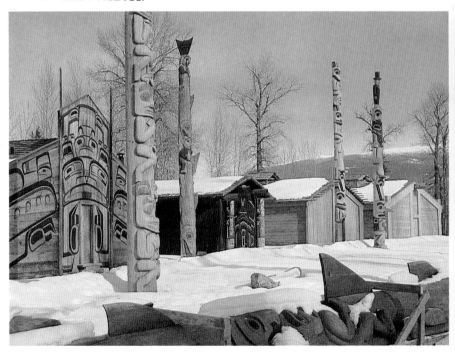

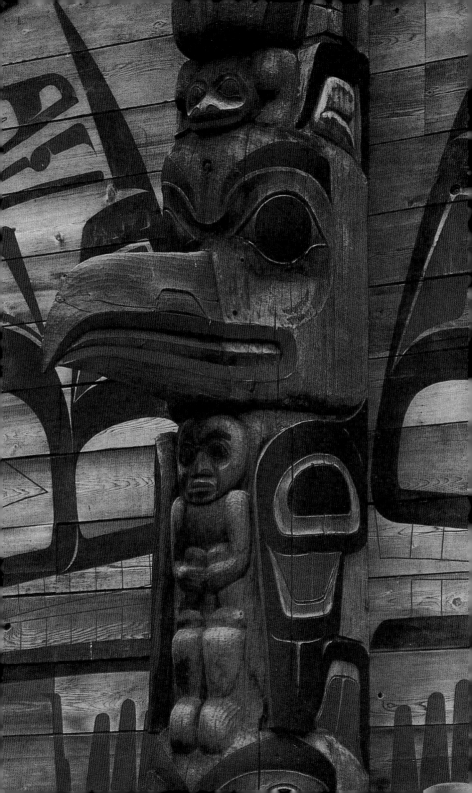

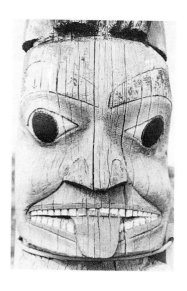

Occasionally grotesque figures symbolized the supernatural or power vision experiences, such as a half-faced human or the demonized face. 'Ksan.

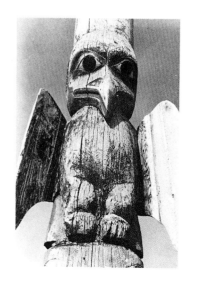

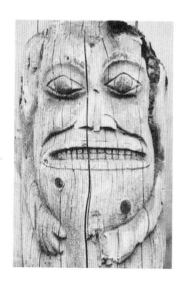

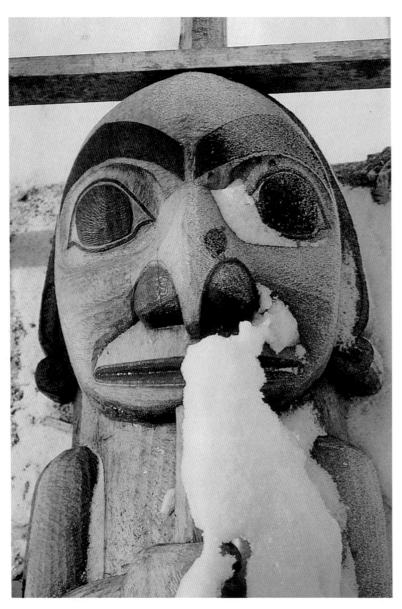

OUTSIDE CORNER HOUSE POST. 'Ksan.

TLINGIT

The Tlingits of southeast Alaska often use a predominance of reds and pastel colors on their poles giving them a distinct appearance. Several fine restoration and replication projects in Ketchikan, Juneau and Haines, Alaska, have permitted many tourists a colorful introduction to this exciting art form.

A HUMAN FIGURE. Combined with memorial pole in unusual way. Ketchikan.

B PART OF MEMORIAL POLE Erected Alaska Square, Seattle, 1975. Crest figure is Strong Boy who was ridiculed for being lazy. However, he exercised a secret power when his uncle was swallowed by a sea lion. Everyone ran away except Strong Boy, who seized the sea lion and tore it in half letting his uncle out alive.

A

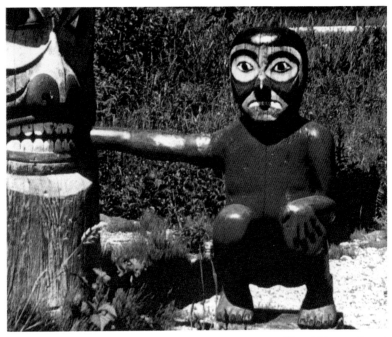

MUSEUM OF MAN NAT. MUS.

30

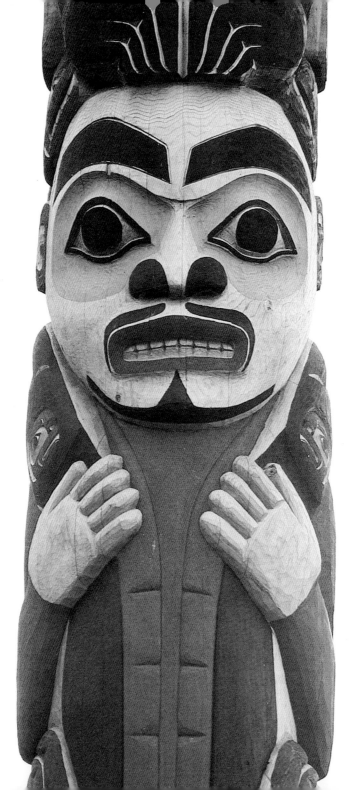

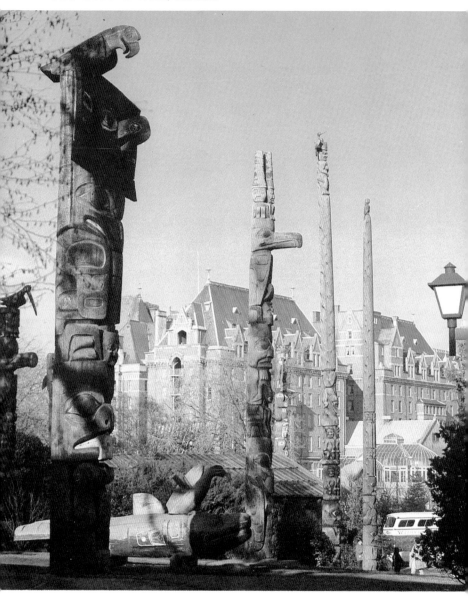

TSIMSHIAN MEMORIAL
HAIDA HORIZONTAL MEMORIAL
HAIDA MORTUARY

TSIMSHIAN MEMORIAL
TSIMSHIAN MEMORIAL
HAIDA HOUSE FRONTAL